THIS WORKBOOK BELONGS TO:

(creative & badass human)

WORKBOOK

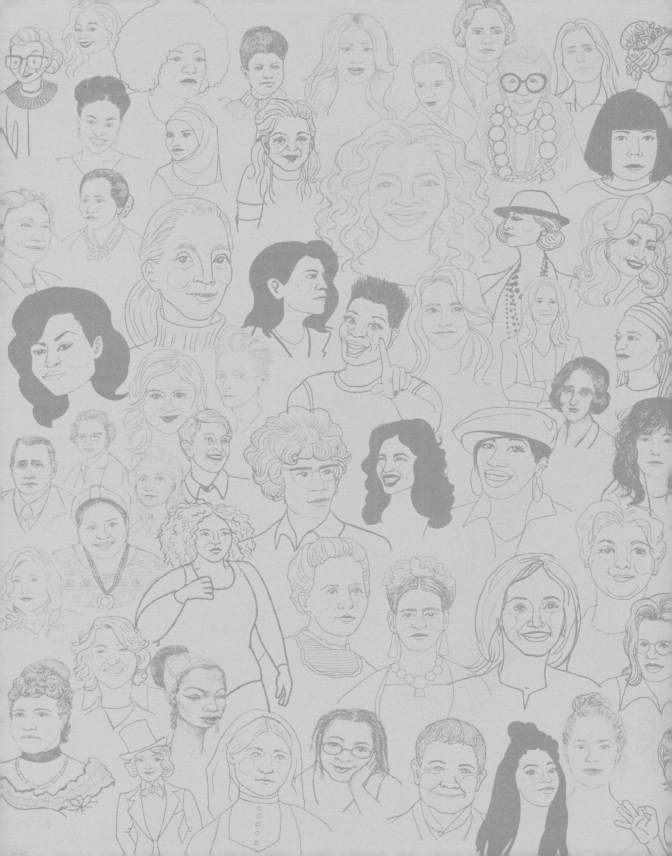

CREATIVE EXERCISES,

CREATIVE EXERCISES,
DRAWING ACTIVITIES,
EMPOWERING STORIES,
AND FUEL FOR YOUR PERSONAL REVOLUTION

BADASS BABE

INSPIRED BY OVER 100 TRAILBLAZING WOMEN

WORKBOOK

BY JULIE VAN GROL

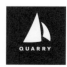

QUARRY

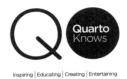

Inspiring | Educating | Creating | Entertaining

Brimming with creative inspiration, how-to projects, and useful information to enrich your everyday life, Quarto Knows is a favorite destination for those pursuing their interests and passions. Visit our site and dig deeper with our books into your area of interest: Quarto Creates, Quarto Cooks, Quarto Homes, Quarto Lives, Quarto Drives, Quarto Explores, Quarto Gifts, or Quarto Kids.

First Published in 2018 by Quarry Books, an imprint of The Quarto Group,
100 Cummings Center, Suite 265-D, Beverly, MA 01915, USA.
T (978) 282-9590 F (978) 283-2742 QuartoKnows.com

Quarry Books titles are also available at discount for retail, wholesale, promotional, and bulk purchase. For details, contact the Special Sales Manager by email at specialsales@quarto.com or by mail at The Quarto Group, Attn: Special Sales Manager, 401 Second Avenue North, Suite 310, Minneapolis, MN 55401, USA.

10 9 8 7 6 5 4 3 2 1

ISBN: 978-1-63159-489-2
eISBN: 978-1-63159-490-8

Library of Congress Cataloging-in-Publication Data available.

Design, Cover Image, and Page Layout: Julie Van Grol

Printed in China

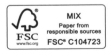

This book is dedicated to all the babes in my life
(that includes you, Mom)

CONTENTS

ATTENTION:

YOU ARE A BADASS.

(YES, YOU.)

You also happen to come from a long line of badass babes across diverse cultures, time periods, and backgrounds. By learning new stories and revisiting familiar ones, you can connect your own badass talents with those of your predecessors and peers. And when we all get together, there's nothing we can't do.

WHAT IS THIS BOOK FOR?

This workbook is designed to empower, inspire, and motivate you to find—and BE—your biggest, best, badass self. It's going to help you unearth, fuel, and cultivate your inner superpowers because they are all in there, waiting to blossom and spill forth in important and creative ways.

It's not always easy to access your inner badass, though. Perhaps you feel helpless or fatigued from daily reminders of injustice and inequality? Perhaps you wonder what you, as an individual, can bring to the table? Perhaps you find yourself losing hope for positive change? You are not alone. One of the most difficult things about staying engaged in a complex and bewildering world is maintaining hope and optimism for the future.

But there's good news. There are many badass women who have come before us, who have defied odds, blazed new trails, and fought against injustice. You will find more than one hundred such stories in these pages. These stories remind us of what individuals are capable of and show us the difference each person can make.

This workbook will serve as a playground for your brain—a means of tapping into your own voice and creative insights. The first step is to leave fear behind and bring out that voice. The activities in this book help you become more confident in your own value and talents. Through them, you can connect your talents and power with the power of all the badass babes who have come before you.

WHO IS THIS BOOK FOR?

The Short Answer: Anyone!

If you have ever been inspired by the tale of one individual's accomplishments, this book is here to help you realize that you can do it too. By owning and telling your own story, through whatever expressive means necessary, you can help change the world for the better.

This book is for folks who have a story to tell, whether it be through writing, drawing, or other methods of sharing. These are creative activities. And everyone can engage in them in their own unique way. So before you start telling yourself "I'm not creative," HUSH. You are.

Whose stories are in the book already? Women, femme-identifying people, and gender nonconforming (GNC) folks. You'll see people from many cultures and backgrounds who are not often represented fairly in media. In one way or another, you'll be able to connect with many of the powerful stories in these pages.

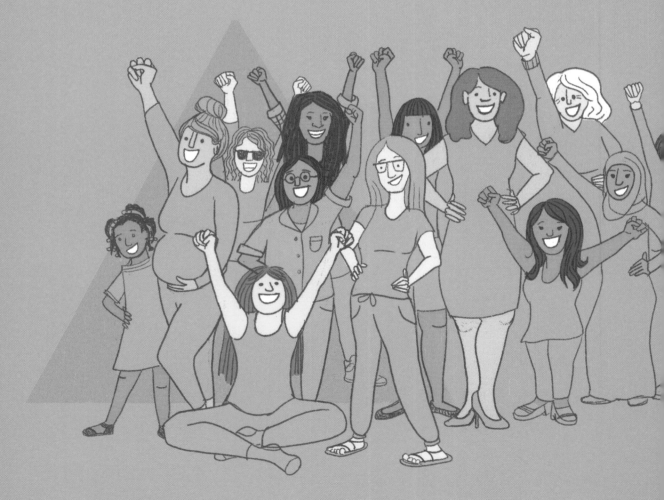

CREATIVITY = POWER!

These babes are all doing power poses. Try it sometime! If you hold one of these stances for at least two minutes, you'll begin to feel why it's called a power pose.

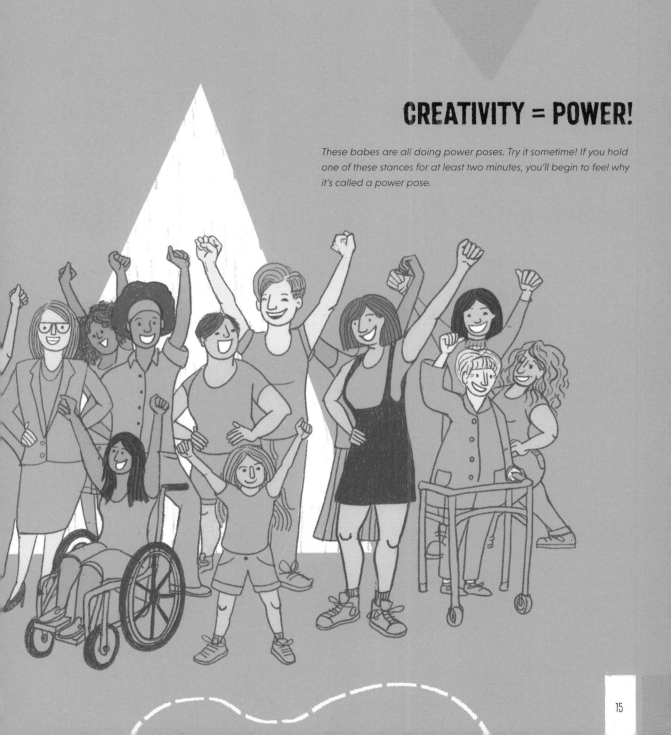

HEARING AND TELLING STORIES

Here's the deal: The best way to take on a problem or a challenging situation is to educate. Educate yourself, your community, and your loved ones. The deeper understanding you have of any given subject, the better equipped you are to improve it. This sounds obvious, but it's easy to forget that it's an essential step to being your most empowered, badass self.

One way to feel empowered, especially when you start out feeling helpless, is to hear and see lots and lots of examples of women, femmes, and GNC folks being total badasses. Have you ever heard the adage, "You gotta see it to be it?" There's a reason it has achieved adage status.

When we see ourselves—or qualities that we identify with, such as gender, age, race, personality, and lifestyle—we feel validated. We feel like we are important. We understand that someone, some-where, knows that we exist and took the time to make us visible.

As you'd imagine, the opposite has an adverse effect. When you don't see yourself in stories, you feel unimportant, invisible, and sometimes even expendable. This lack of representation is called *symbolic annihilation*.

Consider this book a way to roundhouse-kick symbolic annihilation. All the stories you'll find here are different, amazing, and inspiring. These stories are from human beings who come from a wide variety of backgrounds, ethnicities, professions, ages, and gender identities. These stories—combined with your amazing story that you'll add to these pages—can serve as one solid blow to all the media out there that makes us feel invisible. And what's the very best part? **Your story is an essential part of this book.**

This book is a place to safely and playfully express your voice and your story. You don't have to make it perfect. It doesn't even have to make sense. This is your practice space so that you're ready to bring your powerful, amazing voice to whatever endeavor you want to conquer.

CREATIVITY + KNOWLEDGE = POWER!

WHAT WILL YOU FIND IN THIS BOOK?

How Is This Going to Work?

Think of this as a workbook.

You can certainly move through the book in order or flip through it and see whether any stories and activities speak to you on any given day. I recommend familiarizing yourself with each section before diving in. Then use the first section to help warm up your creative side and establish your preferred work methods.

Throughout the book, there are highlights of different stories, quotes, and facts about more than one hundred badass babes in history. You'll be reacquainted with some familiar faces. You'll also encounter unfamiliar faces. Hopefully you'll find stories that reflect your personal experience as well as stories that expand your understanding of what we, as humans, can endure and accomplish.

Each prompt is meant for low-stress, open-minded ideation. Nothing is meant to be perfect. It's a workbook, not a gallery wall!

As you begin to work, give yourself permission to make mistakes. Be corny, be boring, be outrageous—it's all good. If you're having a hard time with one activity, flip around to one that seems easier. Then come back to the original prompt when you're feeling more inspired.

Making and thinking creatively is a habit that gets easier as you do it more often—so take time regularly to work on it!

With each story, fact, or quote, this workbook provides a corresponding prompt or activity for you to use to reflect upon your own badassery!

ASSEMBLING YOUR TOOLKIT

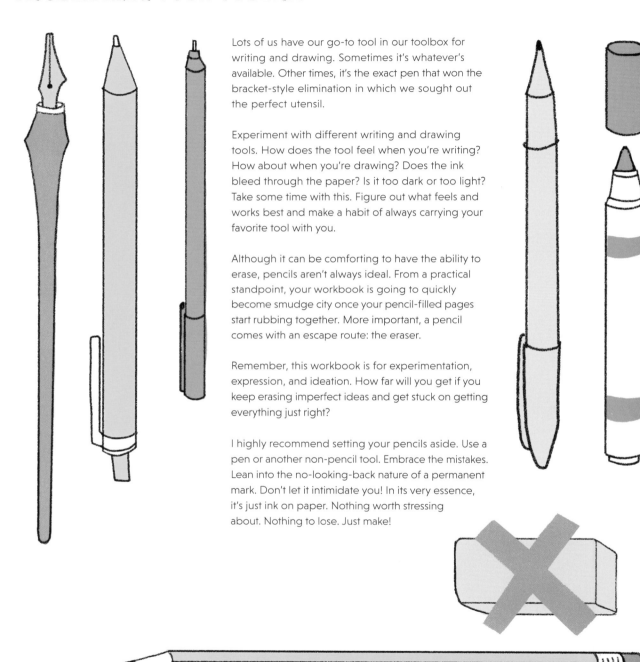

Lots of us have our go-to tool in our toolbox for writing and drawing. Sometimes it's whatever's available. Other times, it's the exact pen that won the bracket-style elimination in which we sought out the perfect utensil.

Experiment with different writing and drawing tools. How does the tool feel when you're writing? How about when you're drawing? Does the ink bleed through the paper? Is it too dark or too light? Take some time with this. Figure out what feels and works best and make a habit of always carrying your favorite tool with you.

Although it can be comforting to have the ability to erase, pencils aren't always ideal. From a practical standpoint, your workbook is going to quickly become smudge city once your pencil-filled pages start rubbing together. More important, a pencil comes with an escape route: the eraser.

Remember, this workbook is for experimentation, expression, and ideation. How far will you get if you keep erasing imperfect ideas and get stuck on getting everything just right?

I highly recommend setting your pencils aside. Use a pen or another non-pencil tool. Embrace the mistakes. Lean into the no-looking-back nature of a permanent mark. Don't let it intimidate you! In its very essence, it's just ink on paper. Nothing worth stressing about. Nothing to lose. Just make!

If you must use a pencil, keep it sharp and ignore that pink thing on the end, okay?

Have other supplies handy in case you feel the need to add or subtract from your workbook. Sticky notes are great for when you feel compelled to jot down a thought, quote, or drawing. Use tape or glue to add an awesome portrait or photograph to this workbook. Whatever you need to do to make this workbook your own, do it!

NOTE TO SELF:
I AM AWESOME.

Test out your writing and drawing tools here!
Notice what works for certain kinds of mark-making.

"The worst enemy to creativity is self-doubt."

—Sylvia Plath

HOW DO YOU DO YOUR BEST WORK?

What kinds of conditions do you need to do your best work?

Try working in public, such as on the bus!

See whether you work better by keeping company with a fellow creative . . .

Or perhaps working in private is better for you, such as on your bed or the couch!

. . . or if you work better by yourself, without any distractions!

What time of day do you work best?

Are you most productive in the morning?

Or do you find that you're most creative
in the nighttime?

Try out different locations, company, and times of day to see what yields the most satisfying
results. Make note of what kind of work you accomplish in different situations, and soon,
you'll be able to set yourself up for optimal creative work time!

Maya Angelou rented out a hotel room. Frida Kahlo had her creative haven in the Casa Azul studio. Virginia Woolf preferred standing while she wrote. Gertrude Stein got most of her writing done while she was out running errands.

Use this space for experimenting with different conditions for your creative work! Make notes in the bottom right box of the time, place, and any other relevant details.

"WE DO NOT NEED MAGIC TO CHANGE THE WORLD, WE CARRY ALL THE POWER WE NEED INSIDE OURSELVES ALREADY:

WE HAVE THE POWER TO IMAGINE BETTER."

—J.K. Rowling

novelist, writer, and magical badass

SELF-CARE, CREATIVITY, AND OUR STORIES

STARTING WITH SELF-CARE

As human beings, much of our understanding of the world—ourselves, one another, the environment—comes in the form of a narrative. We understand most occurrences as stories: the stories we've learned, the stories we tell ourselves, and the stories of what we want to happen.

These narratives can reflect our reality, but can also *affect* our reality. Our sense of understanding can often come from writing, artwork, media, and expression. Creative folks often try to make their own understandings visible, audible, or physical through the act of making. Thus this cyclical nature of creativity, reality, understanding, and making all has a profound effect on our decisions. We vote, buy, date, and choose based on the narratives we've established.

Shouldn't you take the time to have the most informed, inclusive, powerful understanding of yourself and your world? Your story is important. You need to understand its importance to yourself—and inevitably, it's importance to someone else out there! The aim of this workbook is to illuminate the amazing stories of others and show you the power and influence that one person can hold.

As you move through this section, focus on feeding *yourself* through creative and contemplative activities.

1. **Self-reflection**
2. **Self-motivation**
3. **Intention**
4. **Inspiration**

Pema Chödrön was born Deirdre Blomfield-Brown, and she was given her current name while studying Tibetan Buddhist meditation under Chögyam Trungpa. Pema was the first American woman to be fully ordained as a Buddhist monk in the Tibetan tradition. Her name translates as "lotus torch of the dharma" or "lamp of truth."

Pema has several writings on how to cope with pain and suffering, all of which revolve around being fully present for it, rather than avoiding it. Pema points out that we need to focus on and nurture ourselves before we can have any hope for understanding and connecting with others.

With so many things competing for our attention every day, Pema's words serve as a helpful reminder:

START WHERE YOU ARE.

MEET
PEMA CHÖDRÖN

"
When we hear about compassion, it naturally brings up working with others, caring for others. The reason we're often not there for others . . . is that we're not there for ourselves.

If we are willing to stand fully in our own shoes and never give up on ourselves, then we will be able to put ourselves in the shoes of others and never give up on them.
"

> **"We already have everything we need."**
>
> —Pema Chödrön

Instead of focusing on changing and shaping ourselves to fit others' expectations, what if our unique personality, skill set, and talents were already enough? Below list some of your most positive traits.

In this larger space, begin to explore your unique stories—nothing is too small.
Are there life events that have brought out some of your best qualities?

AUDRE LORDE

The late poet, writer, and activist Audre Lorde had a powerful way with words. Her work is known for its gripping, emotive delivery of Audre's perspective on love, anger, race, sexual oppression, and power. Throughout her life, Audre's writing addressed the struggle of social justice, particularly by marginalized communities.

Often the idea of self-care is more accessible to those who have the necessary time and financial resources. Perhaps we also fear that caring for ourselves is a selfish act. Audre's words quickly point out that self-care is not only essential for survival, but a key component for activism. Everyone—regardless of race, gender, economic status, or lifestyle—deserves the space to attend to their own needs.

> "CARING FOR MYSELF IS NOT SELF-INDULGENCE. IT IS SELF-PRESERVATION, AND THAT IS AN ACT OF POLITICAL WARFARE."

One effective and accessible method of self-care is setting boundaries. Boundaries help us define the line between "okay" and "not okay." By setting and adhering to these boundaries, we're able to optimize our energy and interact with others in a more authentic way.

How do we go about defining these boundaries? One method that I've found helpful is to keep a running list. For one week, write down everything that energizes you and that depletes you. At the end of each day, look at your list and try to set boundaries to help minimize the depletion and maximize what energizes you. Is it limiting interactions with certain people? Is it deciding not to let the opinions of others get in your way? Does it involve certain essential acts of self-care each day that must have top priority?

Use the list on the following page to keep track.

What energizes me:	What depletes me:	Boundaries to set:

After compiling your lists, try to identify three key boundaries you can set to ensure that you are taking care of yourself. Then try to distill those three boundaries into one key message or mantra you can remember to repeat throughout the day.

ART CHANGES THE WORLD

As a creative person, one of the first sources of inspiration is often other artists and makers. Most of us have had an experience in which we felt captivated by a painting, read a moving piece of writing, or were floored by a performance. The nature of expressive work like art, writing, and music is that it taps into an emotional connection that has the power to affect and unite even the most dissimilar people.

Let's take time to celebrate artists who have done this well and find ways that we can find inspiration for our own expression.

FAITH RINGGOLD

Faith was raised in Harlem at the tail end of the Harlem Renaissance. Her mother was a fashion designer, and she taught Faith to sew and work with fabric. While Faith continued to foster a love of art as she grew older, she chose art education as a career path in college. (Professional studio art was a field usually reserved for men.)

Faith taught art in New York's public school system, and she also continued to develop her own art practice, which began fueling her participation in political and social activism in the 1960s. Her work focused on the civil rights movement and the burgeoning women's liberation movement, often using her pieces to comment on the exclusion of women from major museum exhibitions (such as the Whitney or MoMA). Faith's work runs the gamut medium-wise, ranging from paintings to quilts to performance art. All her work is dedicated to storytelling, focusing on her experience growing up as a black female in Harlem. Perhaps her most famous piece, *Tar Beach,* was a story quilt that was also adapted into a children's book. The quilt is now part of the Guggenheim's permanent collection.

Faith represents a vital continuation of the Harlem Renaissance through the end of the twentieth century and into the twenty-first. Her work combines the visual and cultural legacy of people such as James Baldwin and Jacob Lawrence with the unique perspective of the intersection of gender, race, and the cultural shifts of the late twentieth century.

Faith's signature story quilts brilliantly combine her familial and cultural tradition of sewing and quilt-making with her painting practice. She learned how to sew and assemble quilts from her mother, who learned from her mother, and so on. Faith made the tradition her own by using her paintbrush to tell the stories of her community and to challenge the stereotypes that plagued the African-American community. Throughout her career, she used her unique and powerful platform to comment on gender and race issues, particularly those that affected her in the art world—and viewers' eyes were opened to her story and that of her community.

MAKING YOUR OWN STORY QUILT

Faith Ringgold is perhaps best known for her story quilts, which she used to tell the story of her roots and her visions of the future. Her work has made the stories of her community and her family visible to millions of people.

Using the space below, draw where you come from. Do it from memory. It doesn't have to be a photographic re-creation. Maybe it's a map, a family portrait, or the classroom of an important teacher from your education. Using only your own brain and your instincts, find a way to convey your roots.

ART FACILITATES UNDERSTANDING

The arts allow us to learn more about the experiences of others. By tapping into the emotions, hopes, and memories of others, we can better empathize with lives that look unlike our own.

"WHETHER YOU SUCCEED OR NOT IS IRRELEVANT, THERE IS NO SUCH THING. MAKING YOUR UNKNOWN KNOWN IS THE IMPORTANT THING."

— GEORGIA O'KEEFFE

KARA WALKER

Kara Walker is a visual artist who is perhaps best known for her larger panoramic pieces that depict black, cut-paper silhouettes against a white wall. These silhouette stories often depict the violent, troubling history of the experience of African Americans, while also addressing issues of gender and sexuality. Kara's courage to continuously make work that depicts brutal and heartbreaking truths about the American past and present ensures clear-sightedness about building a more just future.

HELEN ZIA

Helen Zia is a writer, journalist, and activist. She has dedicated her career to using her voice to stand up against all forms of injustice. Using her vantage point as a second-generation Chinese American, as well as a gay woman, she has helped shed light on the experiences from which she learned firsthand. Using her own story as a springboard, Helen has continued to stand up to racism, income inequality, and gender violence.

ART CONNECTS US THROUGH COMMON EXPERIENCE

When you encounter a piece of writing, music, or visual art that speaks to your lived experience, something incredible happens. The world gets a little smaller, and you feel that you're not alone in your understanding of the world. This is yet another reason why we must all tell our stories, no matter how insignificant they might seem—someone else out there will undoubtedly feel validated because they have felt the same way.

JUDY CHICAGO

Judy is a author, educator, and pioneer in the realm of second-wave feminist art. During a time when the male-dominated art world was primarily focused on minimalism and abstraction, Judy made it a point to create work that was explicitly political and focused on the female experience. Her most famous piece, *The Dinner Party*, acknowledged the women throughout history who we all knew existed but are rarely celebrated. Judy also challenged the binary of high and low art by using media that were usually considered inferior and were primarily executed by women: needlework, textiles, ceramics, and other practices that were usually deemed craft rather than art.

CHIMAMANDA NGOZI ADICHIE

Chimamanda was born and raised in southeastern Nigeria. She grew up reading British and American stories, which featured primarily caucasian characters. Chimamanda found herself writing her own stories about blonde, blue-eyed characters who ate apples and talked about the rainy weather. None of these stories were Chimamanda's reality living in Nigeria, and she felt that she couldn't find herself in literature. As she pursued her writing career as an adult, she became committed to the representation of the complexities and diversity of the African experience.

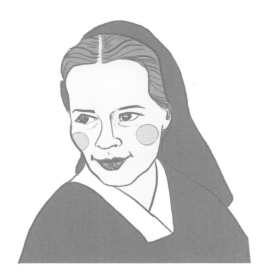

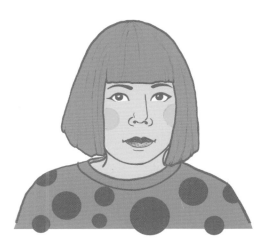

CORITA KENT

YAYOI KUSAMA

Badass nun alert! Corita (also known as Sister Mary Corita Kent) joined the Roman Catholic order of Sisters of the Immaculate Heart of Mary at age eighteen. She began taking art classes and earned her bachelor's degree in 1941 at age twenty-three. She then began teaching in Los Angeles at the Immaculate Heart College in the art department. As the 1960s rolled forward, political tensions between the Catholic church and the order of the Sisters of the Immaculate Heart grew, particularly over the Vietnam War and other humanitarian crises (about which Corita was very vocal). This climate caused Corita to reenter secular life in 1968.

After leaving the order, she devoted her time to art-making. Her focus was on screen-printed posters and designs that served as platforms for her activism.

Yayoi began studying traditional Japanese painting in her youth, but quickly gravitated toward the shifting world of abstract expressionism and the avant-garde. Her work garnered the attention of the burgeoning art scene in New York. Yayoi's work shows that your vision for the world, as told through art, doesn't have to be literal. Yayoi's expressive, symbolic vision embraces bright color, simplified shapes, and graphic patterns.

Her fields of polka dots, or "Infinity Net" paintings as she likes to call them, became her go-to graphic, surreal visual language. She has won numerous awards and recognitions, and she continues to be a tour de force in the international art scene.

TELLING YOUR STORY

Perhaps using your lists from page 34, begin brainstorming about what it is about your story that others might connect with. What life experiences can you speak to? What hardships? What triumphs? What lessons? Start with short descriptions below. If you feel compelled to elaborate, keep writing on the page to the right.

Using what you started on the previous pages, keep working to distill and express your unique story.

Could you capture your story in one phrase or small drawing?

What elements are at the core of your story?

"THE MOST COMMON WAY PEOPLE GIVE UP THEIR POWER IS BY THINKING THEY DON'T HAVE ANY."

—Alice Walker
novelist, poet, activist, and card-carrying badass

STEPS TO EMPOWERMENT

Sometimes all we need is a little reminder of what we're capable of. This chapter is filled with stories and inspiring words from a multitude of badass babes, all of whom found ways to accomplish amazing things despite the obstacles they faced.

Regardless of your interests and background, take time to find common ground with these stories. Look for points of commonality, even if it's simply a matter of being inspired by their fortitude and bravery. Let their stories energize and empower you to face your day and tell your story!

GROUNDBREAKING WOMEN

If you do a little digging, you'll find that history is filled with babes who encountered overwhelming obstacles: social conventions, inhibiting laws, uncertainty, and even physical danger. These women did their thing anyway. The following is a collection of inspiring stories of babes from all sorts of fields and backgrounds. Sit back and bask in the excellence of these stories, and you'll pick your pen back up in a bit.

BABES IN MATH AND SCIENCE

It's no secret that the fields of math and science have a long history of biases against women, despite them having identical or, in some cases, higher qualifications than their male counterparts. Fortunately, there are badasses who stood up against the current of their male-dominated fields and made historic contributions to the world.

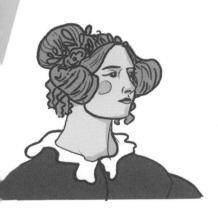

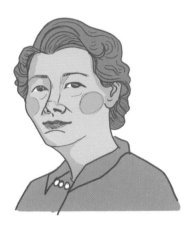

ADA LOVELACE

As a child, Ada thrived in her educational pursuits and quickly became known for her brilliant mind. While working with prestigious computer pioneer Charles Babbage, Ada argued that codes could be created for the Analytical Engine, an early model of computer hardware, to handle letters and symbols. She also developed a theory that the Engine could repeat a series of instructions, known as "looping," that computer programs use today. It is for this and other accomplishments that Ada Lovelace is considered to be the world's first computer programmer.

KATHERINE JOHNSON

Katherine began working for NASA in 1953, and she quickly garnered attention for her impressive knowledge of analytic geometry. Despite her talents and extensive knowledge, she had to continuously ignore gender and racial barriers during her work. When she encountered any resistance to her presence, she would assert that she had the expertise and experience and she deserved a seat at the table. She went on to contribute to the American space program in myriad ways, including the calculation of the trajectory for the first space flight of an American astronaut, as well as plotting the launch window for the 1961 Mercury Mission and the Apollo 11 flight to the moon.

MARIA GOEPPERT-MAYER

Born, raised, and educated in Germany, Maria had parents who recognized her brilliance and encouraged her to pursue her talents in math and physics. She eventually married an American professor and moved to the United States, where she taught and conducted research in the field of theoretical physics. She became the second woman awarded a Nobel Prize in Physics (after Marie Curie) for her proposal of the shell model for the atomic nucleus.

Do you know (personally or otherwise) any babes in the fields of math and science? Draw an honorary portrait! (See the portrait-drawing tips on pages 58–61.)

DRAWING PARTS OF THE FACE

Here are general guidelines for drawing the main elements of the face. Of course, no face is an exact match and the deviations from these standards are often what make us look like us!

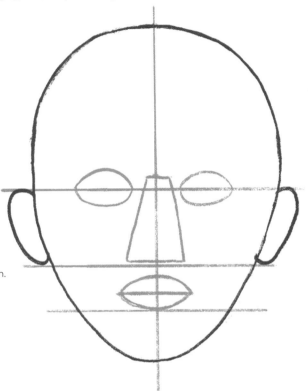

Eyes: They're usually halfway down the face, roughly one eye's distance apart.

Ears: The tops tend to line up with the pupils, and the bottoms usually line up with the bottom of the nose.

Nose: The base is about halfway between the eyes and the base of the chin.

Lips: The bottom edge tends to fall halfway between the base of the nose and the base of the chin. Side to side, the lips tend to line up with the pupils.

EYES:

One of face's most defining features, eyes come in various shapes, colors, and proportions. Pay attention to the details of the lids, shape, and placement, and you'll easily capture anyone's unique peepers!

Lines: When only using lines, pay attention to the darkest points: the upper lash line, any lid crease, the iris, and the pupil.

Shapes: With simpler shapes, usually the iris and the pupil are the focus, along with perhaps the upper lash line.

Shading: Focus on the subtler changes in value. Start with the darkest points first, such as the shadows around the eyes.

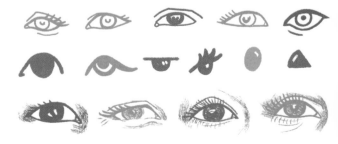

NOSES

Noses come in lots and lots of shapes and sizes. Sometimes someone's awesome nose is what makes them look like them! They can be tricky to draw, however. As with anything, practice makes it easier—eventually, it'll even be fun.

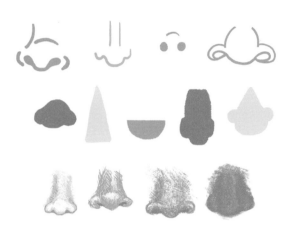

Lines: You can use just a few lines or dots! Focus on the darkest spots such as the nostrils and shadows.

Shapes: Solid shapes can be more playful noses. Just think if you were making this face out of construction paper, what shape would you cut out for the nose?

Shading: Find the darkest and lightest spots. Work to sculpt them by exploring the shades in between.

LIPS

Lips can be intimidating because they come in so many different shapes. As always, focus on the darkest and lightest points and what kind of shapes you see.

Lines: When working only with line, make sure to start with the midline first. Then decide to what extent you'll outline the lips.

Shapes: For more simplified lips, pay attention to the shapes of the top and bottom lips. If you use more than one color, make sure the top lip is darker, as it is almost always in shadow.

Shading: As always with more realistic drawing, start in the darkest point, which is usually the midline and the corners. The next darkest is usually the upper lip.

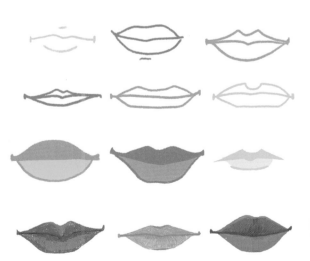

THE PORTRAIT SPECTRUM

Many of the prompts in this workbook involve drawing a portrait—of yourself, someone you know, or someone you look up to. It can be helpful to know that the word *portrait* is a flexible idea.

Traditionally speaking, a drawing of a face can fall on a spectrum. Below, you can see a part of that spectrum, but it arguably extends further in either direction. On the left, you see a simple, playful approach to drawing a face. As you move to the right, the face exchanges a stylized approach for more realism.

You might find that depending on the topic, time constraints, or energy, your drawings fall on different areas on the spectrum, depending on the day. That's perfectly fine! Feel free to take notice of how your work changes, but try to omit any sort of judgment of one approach over another.

In this zone, you only have to work with basic lines and shapes. Low pressure! High fun-factor! The only downside is that the subject might not be immediately recognizable.

As we move to the right, our face can have some defining characteristics, although it's still quite stylized.

As we move toward the middle, portraits become more and more recognizable, but still live in the cartoon world.

Right around this point is what's often called "The Uncanny Valley," where drawings are more realistic than cartoons, but not quite realistic enough to be believable. It usually means the viewer will inevitably be creeped out. It's actually pretty hard to do without a computer, so we'll be avoiding it in this book (thank goodness).

As we get closer to the realistic side of the spectrum, shading and texture become more important than solid lines and shapes.

On the more realistic end of the spectrum, the portrait begins looking more like a photograph. Of course, it can get more realistic than this, but it's time-consuming to achieve. Remember, this book isn't about perfection.

Take some time to practice drawing faces. Use this page to experiment with the different individual features and then assemble them into complete portraits on the right.

FUNNY BABES (PART 1)

Like many sectors of the entertainment industry, comedy has a history of being somewhat of a boys' club. Luckily, there have been plenty of babes who have found ways to get a foot in the door and have made the field better—and funnier—because of it.

ELLEN DEGENERES

Ellen first established herself in the stand-up comedy circuit in Hollywood, quickly garnering attention and stage time on many late-night television shows. She made history when she played the first lead character of a sitcom to openly acknowledge her homosexuality on air. The episode was received with a mix of controversy and applause, and it paved the way to Ellen's current career as a talk show host, LGBTQ advocate, and philanthropist.

CAROL BURNETT

Carol's career spans six decades of television, but she is best known for her variety show, *The Carol Burnett Show*, which ran from 1967 to 1978. *The Carol Burnett Show* won twenty-five Emmy Awards and was ranked number 16 on *TV Guide's* "50 Greatest TV Shows of All Time." Carol's presence as a woman in comedy clearly opened doors for other comedy badasses, such as Lily Tomlin, Amy Poehler, and Tina Fey.

LESLIE JONES

Leslie has become a comedic force to be reckoned with over the past few years—though she's been pursuing comedy since 1987, when she was in college. In 2013, she was hired as a writer on *Saturday Night Live*. A year later, she made history by joining the *SNL* cast at the age of forty-seven, the oldest person to join the cast in the show's history. Leslie's contribution to the cast (besides her explosive comedic energy and hilarious delivery) has made even more history because it is the first time the SNL cast has featured more than one African-American woman.

In the space above, draw a portrait of the funniest babe you know! Or, draw the funniest portrait of the most serious babe you know.

"THE REWARD FOR CONFORMITY IS THAT EVERYONE LIKES YOU BUT YOURSELF."

—RITA MAE BROWN

writer, activist, and nonconformist badass

BABES IN SPORTS (PART 1)

Women have long fought for the chance to compete in physical feats of strength and endurance, often in the face of assumptions of weakness and ineptitude. Those hurdles didn't stop these babes. Here are just a few examples of babes who took it upon themselves to be the strongest, toughest, and most badass athletes they could be.

KATHRINE SWITZER

Kathrine is known for being the first woman to run the Boston Marathon with an official number. In 1967, Kathrine entered her name in the race registration as "K.V. Switzer." During the race, marathon official Jock Semple attempted to physically remove her while she was running, a moment that was famously photographed. Women were finally allowed to run in the Boston Marathon in 1972, putting a wrench in a long history of restrictions on female athletes. Oftentimes, activities such as running were cited, completely unscientifically, as a cause of a slew of health problems, including—but not limited to—"uterus prolapse," or one's uterus falling out of position. Let us all join together in a communal eye roll.

MARIE MARVINGT

Marie was a French athlete and mountaineer. She set the first women's aviation records, was a record-breaking balloonist, and was the first woman to climb several peaks in the Swiss Alps. In 1908, she was unable to participate in the Tour de France due to her gender. Instead of giving up, she rode the entire course after the official race was done. She managed to complete the full course, a feat that apparently only one-third of the official male riders had achieved in that year's race. In 1910, Marie was presented with a gold medal by the French Academy of Sports "for her expertise in all sports." It was the only multi-sport medal the academy ever awarded.

JACKIE MITCHELL

Jackie was one of the first female professional baseball players in history and was recruited to the Chattanooga Lookouts, a minor league team. During an exhibition game against the New York Yankees, Jackie struck out Babe Ruth and Lou Gehrig in succession. Babe Ruth didn't take it very well and reportedly verbally abused the umpire. In a newspaper interview the next day, he said, "I don't know what's going to happen if they begin to let women in baseball. Of course, they will never make good. Why? Because they are too delicate. It would kill them to play ball every day." Sounds a little overly defensive to me. Come on, Bambino. There's no crying in baseball.

After learning the stories from the previous pages, were there any that stood out to you? Was there a story that felt familiar to your experience? One that surprised you? Angered you? Made you laugh? Reflect upon your reaction and begin writing your thoughts. Try to identify why you connect with the story in that way. See whether there's a way you can compare your personal experience with the ones you've just read about.

WRITING TIPS

Sometimes putting your ideas into words is just as challenging, if not more so, as drawing someone's likeness. Below are a couple approaches that can help get your thoughts on paper. Try these tips out with one of the prompts from pages 48, 82, or 132.

It can be easier to begin with lists of words, phrases, and ideas. Start with the impressions and the smaller, simpler pieces. Then you can assemble larger ideas and slowly build a bigger picture.

Once you have a collection of smaller words or phrases, begin elaborating on those in longer phrases or sentences. Try to flesh them out into more complete, descriptive ideas.

After fleshing out your ideas, step back and try to find a way to edit and reorganize them into a cohesive group. Try to find a connecting idea and use that idea as your guiding theme throughout.

If you're writing in a more journal-like scenario, it's best to just start writing. Don't try to organize or edit before you put words on the page. Write now and think later.

LEARNING FROM THE WISDOM OF THE GREATS

It's often helpful to take time to read up on the wisdom of those who came before us. Whether it's the written word, brave actions, or inspiring works of art, we can find that a lot of ground has been covered already. We owe it to ourselves and our predecessors to learn our history.

REBECCA SOLNIT

Rebecca has been recognized for her essays and books that address a broad variety of subjects, including politics, the environment, feminism, and art. Rebecca's essay "Men Explain Things to Me" illuminates the common phenomenon of a qualified, informed woman being patronized by a man, often based on the assumption that he is more knowledgeable solely based on gender. In Rebecca's case, a male attendee at a party spent copious amounts of time explaining the importance of a book that had come out earlier that year. Little did he know that Rebecca was the author of that book. He would have known that if he had listened to the multiple attempts to tell him. It also turns out he didn't even read the book. This phenomenon has become known as "mansplaining," a term that Rebecca did not coin, but has addressed in her writing.

Mansplaining

Have you ever experienced or witnessed a situation like Rebecca's? How did you react? How do you handle a situation in which your authority on a subject is presumed to be inferior? If you were giving advice to a younger version of yourself, what would you say? Jot down ideas and then distill them down into some key phrases that can be practiced.

"Some women get erased a little at a time, some all at once. Some reappear. Every woman who appears wrestles with the forces that would have her disappear. She struggles with the forces that would tell her story for her, or write her out of the story, the genealogy, the rights of man, the rule of law. The ability to tell your own story, in words or images, is already a victory, already a revolt."

"TO PAINT, TO WRITE, TO ENGAGE IN POLITICS—THESE ARE NOT MERELY 'SUBLIMATIONS'; HERE WE HAVE AIMS THAT ARE WILLED FOR THEIR OWN SAKES. TO DENY IT IS TO FALSIFY ALL HUMAN HISTORY."

—SIMONE DE BEAUVOIR

writer, philosopher, and badass feminist

ACTIVIST BABES

Some of the most influential shapers of history have been those at the front of the picket lines or behind the megaphones. When encountering injustice in its infinite forms, these babes took it upon themselves to speak up and act. Let's admire the utter courage and conviction of these amazing women.

bell hooks

bell hooks is an activist, educator, and author. Her work focuses on the overlap of structures—race, gender, class, and ability—and how these all perpetuate systems of power and oppression. She is known for her postmodern mode of thinking and writing, but also for her commitment to making her work as accessible as possible to as many people as possible. bell argues that literacy is a revolutionary tool, and she points to our ability to learn, read, and challenge hegemonic structures as the foundation of bringing positive change and unity.

HARRIET TUBMAN

Born into slavery around 1820, Harriet fled at the age of twenty-nine. Not only did she undertake the brave act of escaping slavery herself, but she also had the astonishing courage to return for several family members and eventually dozens of other families. During roughly thirteen missions, Harriet rescued more than three hundred slaves over the span of twenty years, earning her the nickname "Moses." During the Civil War, Harriet became a union army scout and spy and liberated more than seven hundred slaves.

SOJOURNER TRUTH

Sojourner's unbelievable courage to fight for freedom for herself and her family is impressive enough. She was one of the first black women to successfully challenge a white man in court. She spent her life fighting for racial equality, gender equality, and religious tolerance to boot. She's perhaps best known for her speech on racial inequalities at the Ohio Women's Right's Convention in 1851, "Ain't I a Woman," which also happens to be the title of one of bell hooks' first books.

HELEN KELLER

Helen has become historically known for being the first blind-deaf woman to earn a bachelor of arts degree. Into adulthood, Helen became an advocate for people with disabilities but she was also an outspoken suffragette, pacifist, birth control advocate, and an avid supporter of the NAACP. She was also one of the founders of the American Civil Liberties Union. Helen is the ultimate example of overcoming countless obstacles and using one's voice to lift up all disadvantaged communities, especially when she fought so hard for that voice.

MORE BADASSERY THIS WAY!

ANGELA DAVIS

Angela is an American activist, scholar, and author. Her life has been devoted to activism and education. She established herself in her youth as a force in the fight against oppression both in the United States and around the world. She came up against strong opposition during her career, but she has emerged as one of the key figures in American activism. She continues to speak, teach, and write on feminism, African-American studies, social consciousness, and the prison industrial complex in the United States.

GLORIA STEINEM

Gloria's name has become inextricably linked with the women's movement and second-wave American feminism. She began her work in the public sphere as a freelance writer in the 1950s and 1960s. She has been a great example of a second-wave feminist who, in face of a changing landscape and increasingly intersectional dynamics, has not been afraid to continue learning and even correcting past ideas, all while continuing to use the power of her voice.

BERTA CÁRCERES

Berta was a Honduran environmental activist and fierce defender of the rights of indigenous people. She garnered attention for her grassroots campaign that pressured one of the world's largest dam builders to back out of the construction of a dam over the Río Gualcarque, a river in western Honduras that is sacred to the indigenous Lenca people.

Berta was assassinated in her home in March 2016. A year before she died, Berta acknowledged the risks she was taking by being such a visible and passionate activist. There had been multiple threats on her life and those of her supporters. Still she insisted that she keep fighting for the rights of the indigenous people of Honduras and the protection of the natural environment against the encroachment of development projects.

SYLVIA RIVERA & MARSHA P. JOHNSON

Both of these American activists accomplished amazing things independently. Together they worked to create STAR: Street Transvestite Action Revolutionaries ("transvestite" was later changed to "transgender"), an organization that worked to support New York City's LGBTQ youth, particularly homeless queer youth and transwomen of color.

What have you learned from the women of the previous pages?
What of their stories can you share with others? With whom can
you share these stories?

MUSICAL BADASSES

Lucky for us, there are plenty of examples of badass babes in music. Many of them found ways to make space for women in male-dominated spaces and revolutionize the genres themselves.

NINA SIMONE

Nina was an American singer and songwriter, as well as a civil rights activist. She solidified her place in history with her unique combinations of a broad range of styles, all of which came together with her soulful voice and her piano playing. Nina, along with Sister Rosetta Tharpe, are among the nominees for induction into the Rock and Roll Hall of Fame for 2018.

SISTER ROSETTA THARPE

Rosetta was an American musician, often referred to as "The Godmother of Rock 'n' Roll." Her unique combinations of gospel, soul, and rhythmic guitar work paved the way for the likes of Chuck Berry, Little Richard, and Elvis Presley. Johnny Cash even cited her as his favorite singer and biggest inspiration.

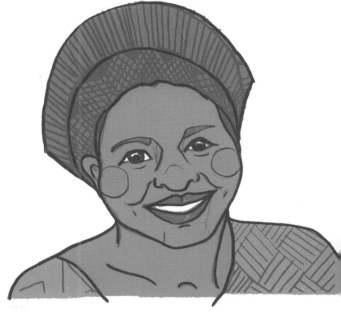

MIRIAM MAKEBA

SELENA QUINTANILLA

Selena is considered the queen of Tejano music, a style of Mexican-American music that mixes the styles of folk and popular music. At a young age, Selena established herself as a pillar in Mexican-American culture as a singer and entertainer. Her life and career were tragically cut short at the young age of twenty-three, but her music lives on and is responsible for bringing a key genre into the mainstream.

Nicknamed Mama Africa, Miriam used her unique musical stylings to build a platform to advocate for change. She used her voice to stand up for civil rights and speak out against apartheid in South Africa, and she even eventually became a goodwill ambassador for the United Nations.

Take some time to listen to the music of these women. Use the space on the following pages to show how the music makes you feel. It might involve drawing the performers, the space they might have performed in, or something more abstract, such as the sounds and the energy. Don't think too much! Just draw what comes to mind.

EXPRESSIVE DRAWING

It's often difficult to find ways to visually express more abstract concepts such as emotions, sounds, or complex ideas. It gets easier if you take time to understand how you associate certain marks and designs with a symbol or concept. Explore some general rules—keeping in mind that there are always exceptions. Then experiment with using mark-making as a means of expressing ideas beyond the literal world.

Vertical lines tend to be associated with height, growth, and upward motion. Horizontal ones often suggest a feeling of rest because they are parallel to the earth.

Depending on their spacing and thickness, marks can represent movement, emotion, or physical objects. Notice how the two examples give different impressions.

The kinds of marks you make, combined with the space between them, can invoke solid objects or atmospheric elements. What do these marks above remind you of?

Diagonal lines are considered more dynamic and invoke movement. More organic lines can also imply action. Notice what a difference the various waves make.

Check out the three examples of expressive lines below. What do you think of when you look at them? Write your response in the box below each shape. Then in the circles below, draw your own lines! Then either assign a meaning yourself or ask a pal to tell you what they see when they look at your drawings.

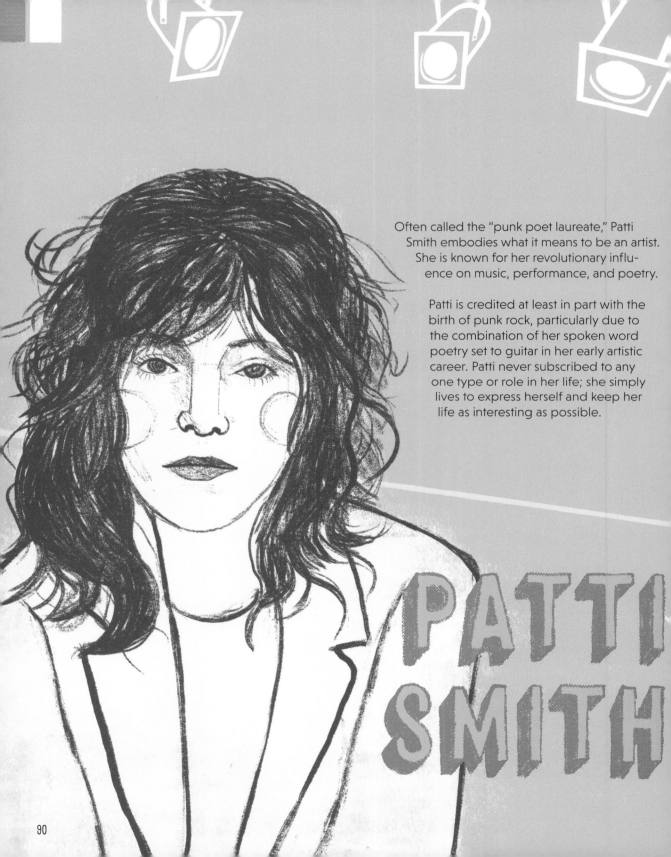

Often called the "punk poet laureate," Patti Smith embodies what it means to be an artist. She is known for her revolutionary influence on music, performance, and poetry.

Patti is credited at least in part with the birth of punk rock, particularly due to the combination of her spoken word poetry set to guitar in her early artistic career. Patti never subscribed to any one type or role in her life; she simply lives to express herself and keep her life as interesting as possible.

PATTI SMITH

Draw yourself on stage channeling your inner Patti!

"In art and dream may you proceed with abandon. In life may you proceed with balance and stealth."

Pick your musical prop!

REDEFINING "FEMININE"

All of us have experienced some degree of pigeonholing regarding our gender and identity. There are a lot of conversations happening in popular culture and on an academic level about the distinctions between your body, your identity, and your expression. Each of these distinct sides of our personhood holds systems of stereotypes and expectations, and many of us internalize lots of limitations placed on us based on these stereotypes. If you have a certain body, you might be expected to only perform certain tasks. If you have a certain identity, you must have a certain kind of body. You wear a specific kind of clothing; thus you must have this kind of personality or identity.

It doesn't take long to realize that this is bullshit. The sooner we realize it for ourselves and each other, the better. Luckily, lots of amazing babes have been paving the way for constructive conversations. We've made progress, but there's still lots of work to do.

These discussions matter for lots of reasons. In our workbook, it's important that your body, identity, and expression do not prevent you from feeling like using your unique voice. How freeing would it be to like what you like, feel what you feel, and do what you feel compelled to do without wondering whether it's appropriate, justified, or good enough? What can we do to make that scenario a reality?

Growing up, what things did you like or care about? Were there things that were considered inherently feminine? Did you like things that departed from that idea? Draw a little you with all your favorite things!

What would you say to this little babette today, if you could?

CHALLENGERS OF GENDER CONSTRUCTS

These babes, through their own unique strengths and life stories, shed light on the complex topic of gender and identity, showing that it exists beyond a binary.

LESLIE FEINBERG

Leslie was an activist and author, particularly active on behalf of those oppressed because of their sexual, ethnic, racial, or gender identities. Her writings laid much of the groundwork for the language and awareness around the study of gender and identity, and she was instrumental in bringing the conversation to the mainstream.

PAULI MURRAY

Pauli played an active role in the American civil rights movement as an activist and through her legal contributions to the greater discussion on equality. Pauli's experiences were in part shaped by her fight against racism and sexism, as she was openly in same-sex relationships and often spoke of what is today called *gender nonconformity*, often favoring a masculine gender expression in her twenties and thirties.

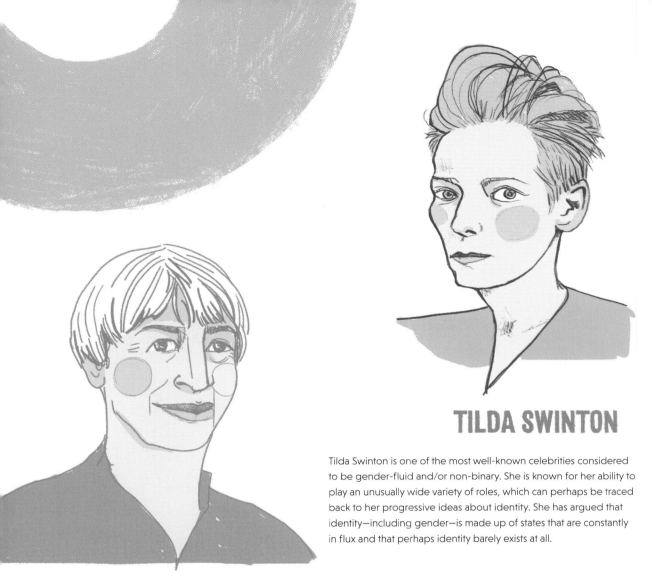

TILDA SWINTON

Tilda Swinton is one of the most well-known celebrities considered to be gender-fluid and/or non-binary. She is known for her ability to play an unusually wide variety of roles, which can perhaps be traced back to her progressive ideas about identity. She has argued that identity—including gender—is made up of states that are constantly in flux and that perhaps identity barely exists at all.

URSULA K. LEGUIN

Ursula contributes to the conversation of gender, identity, and social constructs through her fiction writing. She is best known for her science fiction and fantasy stories, many of which address the complexity of gender and sexuality, often focusing on characters that are gender fluid. As in most sci-fi and fantasy literature, her characters often live in other worlds, but her themes and plots are reflective of very Earthly phenomena. Ursula grew up in a household of social scientists, and she was well aware of the complex workings of social constructs on individual psychology. By presenting her characters and communities in accessible genres such as sci-fi and fantasy, Ursula allows her readers to see commonalities between themselves and the stories.

FIRSTS & BOUNDARY-BREAKERS

What we see is often what we perceive as possible. Sounds obvious, right? But what happens if something hasn't been done before? Well, there's a first time for everything. Here are some babes who didn't let the idea of being first stop them from getting the job done.

SHIRLEY CHISHOLM

In 1968, Shirley became the first African-American congresswoman. Shirley's work in the U.S. Congress was dedicated to fighting for education opportunities and social justice. She served on the Education and Labor Committee, and she was one of the founding members of both the Congressional Black Caucus and the National Women's Political Caucus. She was also the first woman to run for the Democratic Party presidential nomination.

WILMA MANKILLER

Wilma was the first female to serve as principal chief of a Native American tribe in the modern era and the first female principal chief of the Cherokee nation. She accomplished incredible things for her community, including doubling employment, increasing educational achievement, and drastically decreasing the infant mortality rate.

MARY ANN SHADD CARY

After the Fugitive Slave Act was passed in 1850, which threatened to return northern blacks and escaped slaves, Mary Ann and her family moved to Ontario. In Windsor, Mary Ann founded a racially integrated school and cofounded *The Provincial Freeman*, an antislavery newspaper, of which she was also a writer and editor. She was the first black woman in North America to publish and serve as editor of a newspaper. Mary Ann also spent her life travelling around the United States and Canada, speaking and advocating for full racial integration through education and self-reliance.

IDA B. WELLS

Born into slavery several months before the Emancipation Proclamation was issued, Ida B. Wells had parents who taught her how to read at an early age, and they served as vivid examples of activism and social justice for African Americans during Reconstruction. She lived a life fighting, committed to an array of social justice issues. During a march for universal suffrage in Washington, D.C., in 1913, she was told that black women would have to march at the back of the parade. After considering forgoing the parade, she simply repositioned herself at the front at the last minute, and she marched alongside white co-suffragists Bell Squire and Virginia Brooks.

MORE BADASSERY THIS WAY!

NELLIE BLY

Nellie's entrance to the journalism world was a scathing response to a letter published in her local paper titled "What Girls Are Good For," written by a man known as the "Quiet Observer." The letter argued that women belong at home and called the working woman "a monstrosity." Bly's response was so well written that the editor of the paper offered her a job. Bly changed the world of journalism through her exposé of a women's mental asylum in New York as well as a solo trip around the world she made in seventy-two days, beating the Jules Verne character by eight days.

Can you think of any other ladies who were firsts? Draw their portraits being their awesome selves and describe what they did. Consider sharing your drawing/writing with friends or even on social media! Their stories need to be heard!

BREAKING CONVENTIONS WITH FASHION

History is filled with women who defied conventions, including those who refused to be pigeonholed into dressing or presenting themselves in a certain way. Fashion is one of the many ways we can express our unique personalities, but certain conventions are often hiding places for oppressive norms. Let's take a moment to celebrate just a handful of babes who have done their part to throw convention to the wind.

COCO CHANEL

Coco's name has become synonymous with high fashion, but at the core of her legacy are her signature, convention-breaking suits and dresses. She borrowed motifs from menswear and emphasized comfort over convention, which was a novel idea for the time, especially in women's fashion. Her collarless jackets and loose-fitting slacks brought the dawn of a new age for women's fashion. Buh-bye, corset. Hello, comfort.

MARLENE DIETRICH

Marlene was an actress and singer whose illustrious career was matched only by her legacy as fashion icon. She was among the first public female figures to unapologetically sport menswear—including pants! Shocking stuff! She wasn't shy about wearing a three-piece suit or a top hat. She has sometimes been called the queen of androgyny.

VIVIENNE WESTWOOD

Vivienne is a designer responsible for disrupting the status quo in fashion design by bringing in the aesthetics of the burgeoning punk movement. Unafraid to use outrageous and sometimes taboo motifs, Vivienne was instrumental in bringing metal studs, safety pins, and chains onto the runway. Her work turned propriety on its head and opened the fashion world's eyes to the punk movement.

HALIMA ADEN

IRIS APFEL

Iris is a fashion icon and retired business owner, known the world over for her otherworldly sense of personal style and audacious use of fashion accessories. Iris refuses to fade into the background, as women are socially expected to do after their sixties, especially in the world of fashion. But that doesn't mean she chases after youth. As of 2017, she is an unapologetically ninety-six-year-old fashionista.

Halima is a Somali-American fashion model who has a trail of broken conventions in her wake. She was the first contestant in the Miss Minnesota USA pageant to wear a hijab and a burkini, as well as the first hijab-wearing model to be signed to a major modeling agency. Halima serves as a beacon of progress and her work continues to represent one more way, among many, that we can understand beauty.

Think of the look that makes you feel the most powerful. It might be the most comfortable or low-key getup. It might be your fanciest. It might have the most intimidating heel height and/or shoulder pads! Whatever it is, own it. Draw your powerful self in this way.

Draw other favorite items from your wardrobe and write down how they make you feel when you wear them!

GOING HEAD-TO-HEAD WITH DUDES

Women and femmes are often subjected to a separate standard from the dudes. These separations usually serve to maintain hierarchies and stereotypes that femmes aren't as strong, smart, or talented as their male counterparts.

Of course, if you're reading this book, you already know that those separations and stereotypes are nonsense. In case you need specific examples, let's bask in the glory of the following babes.

BILLIE JEAN KING

Years after Billie established herself as a tennis tour de force, she became known worldwide in 1973 when she played an exhibition match dubbed "The Battle of the Sexes." Bobby Riggs, a top men's player (considered at one point the world's #1 tennis player), had taken on promotional challenges in tennis, and at the same time was spouting chauvinist garbage about women's tennis, claiming the women's game was so inferior that his fifty-five-year-old self could defeat the top female player. King had received multiple offers to play against Riggs, but finally accepted after Riggs defeated tennis player Margaret Court in a separate match and a $100,000 prize for the winner was put on the table. Bobby announced his inevitable victory against Billie with comments such as, "I'll tell you why I'll win. She's a woman and they don't have the emotional stability," and "Women belong in the bedroom and kitchen, in that order." On September 20, 1973, an audience of 90 million people watched Billie Jean hand him his ass, winning the match and the $100,000.

MARIE CURIE

Marie was not only the first woman to win a Nobel Prize, but is the first and only woman to win two. She received prizes in both physics and chemistry, and yes, she was the first to win a prize in two different categories. In case that wasn't enough firsts for you, she also became the first female professor at the University of Paris. Many of these accomplishments occurred during a time that women were not yet allowed to vote and were often seen as little more than property. Did that stop Marie from basically drafting the plans of an entire field of nuclear physics? Hell no. Although she had a strong partnership and research collaboration with her husband, Pierre, she often worried that he would get credit for her discoveries, and thus she has made it clear in her writings which work was hers. Her concerns were justified, as her name wasn't even included on her initial Nobel Prize nomination. (Luckily, she had some folks in her corner who brought it up to the prize committee, and her name was added to the nomination.)

MISSY ELLIOTT

Since her entrance into the music scene, Missy's presence has constantly been a challenge to stereotypes and limitations placed on women. She stood up to misogynist notions of how women in hip hop and rap should look, behave, and perform. She established herself as a strong, competitive entrepreneur and paved the way for countless ladies in the scene that came after her. Her resume is pages upon pages, including four Grammy Awards, songwriting and production for many big names in hip hop, and the creation of her own label, The Goldmine, Inc. More than twenty years into her career, Missy continues to surprise her old fans and create new ones, and it's clear that she's not going anywhere.

GIRLS TO THE FRONT!

KATHLEEN HANNA

Kathleen is best known as the frontwoman for the feminist rock bands Bikini Kill and Le Tigre. She was truly a pioneer for making space for girls and women in the punk scene by making her activism an essential part of her music and performances.

Using punk flyers as inspiration, make a cut-and-paste flyer for an event you have coming up or one that you'd like to make happen. Even if you're the only one to ever see it, let it help you get pumped!

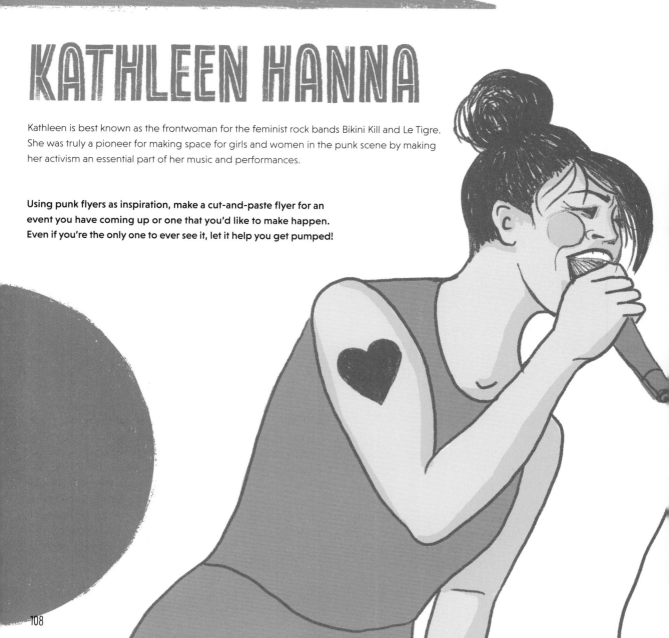

Draw the grown-up you to complement little you (page 94). Draw
yourself surrounded by the things that matter most to you today.

EXPANDING WHAT WE SEE AS POSSIBLE

Thus far in the book, we've seen dozens of babes who have taken on incredible challenges and defied great odds. It's quite possible that their stories have already broadened your scope of how you define possible. Just to be sure, here are even more tales of badassery.

Let's learn and celebrate babes who have revolutionized their fields, overcome seemingly impossible odds, and used their voices to educate and advocate for the betterment of all.

FUNNY BABES (PART 2)

Women are funny. Period. Lucky for us, we have lots of reminders of all the ways that babes can make us laugh, which is becoming more and more important these days.

TINA FEY & AMY POEHLER

There's no denying that Tina and Amy shook up the boys' club of American comedy. The two met in Chicago working for The Second City improv, and they reunited in New York on *Saturday Night Live*. Tina was the first lead female writer for *SNL* in the show's twenty-seven-year history. Amy was the first woman to move from "featured cast member" to "full cast member" in her first season on the show. Tina and Amy were the first two women to coanchor "Weekend Update," a segment long-occupied by either solo men or a man/woman team.

Both Tina and Amy went on to be leads in comedy shows that focused on strong, funny women kicking ass in male-dominated fields. Amy still calls Tina her "comedy wife."

PHOEBE ROBINSON & JESSICA WILLIAMS

Phoebe and Jessica met while taking improv classes at Upright Citizens Brigade (founded, in part, by Amy Poehler!) and immediately knew they wanted to be friends. Together, they host *2 Dope Queens*, a hilarious, joyful podcast featuring guests from a wide variety of backgrounds and experiences. Phoebe and Jessica emphasize that their show is a space where everyone can be the star of their own stories and that those stories represent a very wide range of experiences, giving listeners an opportunity to broaden their understanding of the joys, difficulties, and hilarity that exists in all walks of life.

SAMANTHA BEE

Samantha has garnered lots of attention as the sole female voice in late-night television. She got her start as a correspondent on *The Daily Show*, and she has a unique, fearless, and undeniably funny approach to political satire. Samantha abandons the quintessential late-night desk and stands proudly in front of the camera, donned in her blazer, delivering fast-paced punches to the absurd goings-on in American politics. Her show, *Full Frontal with Samantha Bee*, has shaken up the preconceived notions of what late-night comedy can be. We look forward to more Samantha and to seeing more babes in late-night television.

BABES IN SPORTS (PART 2)

The world of sports is where we see some of the most impressive physical feats performed by badass babes. We're so lucky to have these amazing examples of what the human body is capable of—regardless of what you've got in your swimsuit area.

SIMONE BILES

Simone has shattered records across the board. She already has a move named after her: a double layout with a half-twist and a blind landing, which is a move no one has ever performed in competition before. They call it "The Biles," and I'm pretty sure it defies the laws of physics.

FLORENCE GRIFFITH JOYNER

Florence Griffith Joyner (a.k.a. Flo Jo) is still considered the fastest woman of all time, and her records from 1988 for the 100- and 200-meter dashes have yet to be broken. In 1993, she was appointed as cochairperson of the President's Council on Fitness and Sports by President Bill Clinton. She died in 1998, but boy did she leave her mark on her sport and the whole damn world.

SERENA WILLIAMS

A powerhouse in the world of tennis, Serena has been ranked as the world's #1 singles player on eight separate occasions, as well as being declared the world's top player and holding the title for 319 weeks in total. She holds the record for most Grand Slam titles in the Open Era with a whopping thirty-nine in singles, doubles, and mixed doubles.

Beyond her countless other wins, titles, and awards, Serena represents a new era of women's athleticism with her undeniable power and her advocacy for equal pay for female athletes. Serena also founded the Serena Williams Fund, which focuses on both advocating for education and supporting victims of senseless violence. The organization has built schools and resource centers to help bring support and opportunity to as many people as possible.

DRAWING THE FIGURE

When drawing portraits, it's often just as important to show the person's body as it is to depict the face. But that can be tricky! Like most things, it gets easier with practice.

There are as many approaches to figure drawing as there are unique bodies to depict! Here is one method: break down the body into shapes. You might use more complicated shapes; you might use simpler ones. Starting with a general form and refining from there is much easier than starting with the details.

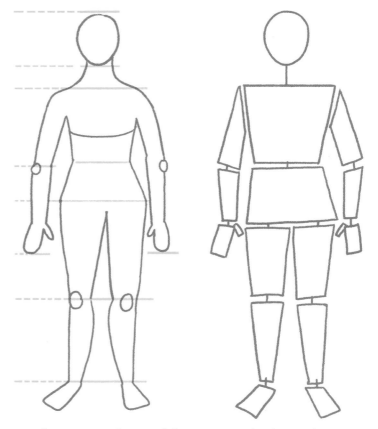

top of the head

bottom of the chin

shoulders

waist and elbow

hips

finger tips (usually mid-thigh)

knees

ankles

Of course, these proportions and sizes can completely vary from person to person and body to body. But that's the awesome part! Each body makes unique shapes, and no shape is superior or inferior to any other.

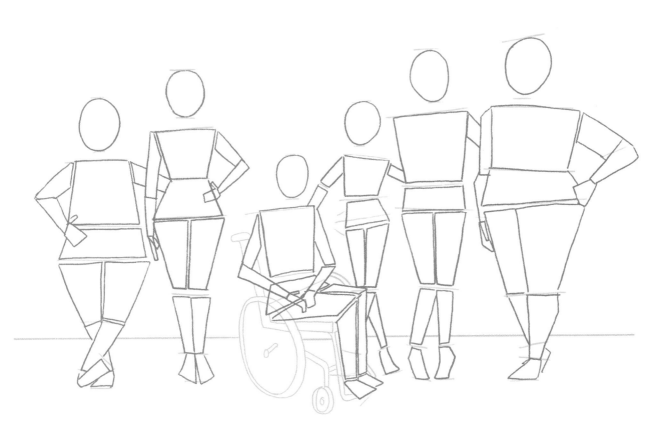

Once you break down a figure by basic shapes, you can focus on the unique proportions and angles. Then incorporate details to whatever degree you feel aligns with what you see in your mind's eye. The more details you add, the more realistic the drawing will be. If you leave it more simplified, it will have more of a stylized impression. (See the portrait spectrum on page 60.)

Use these pages to practice different approaches to drawing the figure.

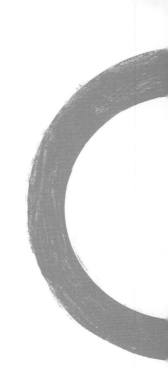

MISCELLANEOUS BADASSERY

Sometimes, inspiration cannot be easily categorized. Just to make sure as many bases are covered as possible, here's a lovely medley of babes from many walks of life. What's their uniting trait? Badassery, of course.

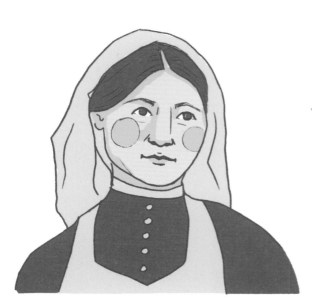

FLORENCE NIGHTINGALE

Florence is known as the founder of modern nursing. She gained attention after serving in the Crimean War organizing and leading a corps of nurses, for which she had developed a training program for the treatment of wounded soldiers. One of her most noted accomplishments was drastically improving sanitary conditions in these hospitals. After the war, she began establishing a system that would professionalize the position of nursing for women, and she founded the school of nursing at St. Thomas' Hospital in London.

She dedicated the remainder of her career to writing for the curriculum of her nursing school and sharing her knowledge of medical care. To this day, new nurses take the Nightingale Pledge, and the highest international honor a nurse can achieve is the Florence Nightingale Medal.

HILDEGARD VON BINGEN

Hildegard joined the monastic life around age fourteen, and by age thirty-eight, she was elected as a leader of the church. As soon as she was appointed, she didn't hesitate to make changes to the church. She continued her uncommon studies of music, philosophy, and literature, and she emboldened other women to do the same. Hildegard invented an alternative alphabet, a form of modified medieval Latin, which is believed to have been used to increase solidarity among her nuns. She also helped pull the convent out of debt by opening up the monastic life to wealthier women by loosening restrictions such as wearing jewelry, which grew their convent to more than fifty women.

She has been quoted as saying, "Woman may be made from man, but no man can be made without a woman." Mic drop.

MARY SHELLEY

MAYA LIN

Mary is best known for her 1818 novel *Frankenstein, or, The Modern Prometheus*, which is considered one of the earliest examples of science fiction. She was the child of the feminist philosopher, Mary Wollstonecraft, and the philosopher and novelist, William Godwin. Having come from two intellectually advanced parents, she put her intellectual inheritance to good use. Despite not having any formal education, Mary showed immense curiosity and intelligence. At age sixteen, Mary struck up a romantic relationship with poet Percy Bysshe Shelley. At nineteen, while traveling with her stepsister Claire and Percy, Mary began crafting *Frankenstein*. She finished the story a year later, publishing it anonymously. (The only sign of it being Mary's work was the dedication to Mary's father.)

When Maya was twenty-one years old and still an undergraduate student at Yale University, she won a national competition for the design of the Vietnam Veterans Memorial in Washington, D.C. Her design concept was to create an open wound in the earth's surface to signify the loss of the soldiers, whose names would be engraved there. There were plenty of objections to her being the designer, often citing her gender, her Asian ethnicity, and her student status. Her design was indeed built, and it is considered one of the most moving and memorable sights in Washington. She went on to have a successful career in sculpture, design, and architecture, but she established her name in the history books from the beginning.

MORE BADASSERY THIS WAY! ▶

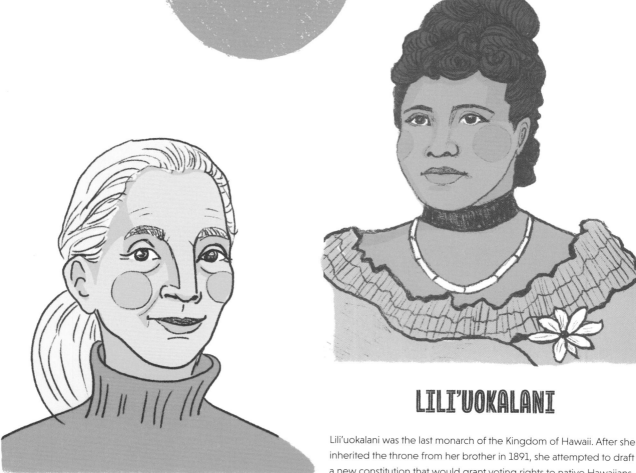

LILI'UOKALANI

Lili'uokalani was the last monarch of the Kingdom of Hawaii. After she inherited the throne from her brother in 1891, she attempted to draft a new constitution that would grant voting rights to native Hawaiians and Pacific Asians and restore veto power to the Kingdom of Hawaii. This constitution did not come to pass, and a military-backed coup dethroned her and a provisional government was formed.

Lili'uokalani continued to fight against annexation of the Hawaiian islands by the United States through different means, despite being placed under house arrest. She acted as the head of the Onipa'a ("Stand Firm") movement, whose motto was "Hawaii for the Hawaiians." Despite her efforts, Hawaii was annexed by the United States in 1898. That year, Lili'uokalani continued to preserve native Hawaiian culture in another way and composed the song, "Aloha 'Oe" (Farewell to Thee), a song that quickly became—and has continued to be—a cultural symbol for Hawaii.

JANE GOODALL

Jane is a British anthropologist and primatologist and is considered the world's number one expert on chimpanzees. She spent more than fifty years studying the social patterns of wild chimpanzees in Tanzania, which resulted in an increased awareness of how the similarities between great apes and humans exist not only on the genetic level, but in emotional and social ways as well. Since her groundbreaking study, Jane has used her time to advocate for environmental conservation, and she has been honored for her humanitarian work.

What other babes can you see amongst these babes? Draw their portrait and tell their story here!

Draw babes in your field or your dream field. Visualize how positive change would look.
How do the participants act? What are the outcomes? Draw yourself being a leader!
Perhaps try out making a comic to show how this world looks.

OVERCOMING IMPOSSIBLE ODDS

Every once in a while, we encounter stories that shake our grasp of what humans are able to endure. Here are just a handful of stories of women who rose above unimaginable physical and circumstantial hardship and *still* accomplished greatness. A lot of us are fearful of our ability to face uncertainty or danger, but perhaps we need to give ourselves more credit. These babes serve as a reminder of how strong we can all be.

FRIDA KAHLO

Frida is a staple in art history, having made a name for herself through her paintings, primarily self-portraits connecting personal identity, Mexican pop culture, and folk art. Her raw emotional depictions shed a light on a life fraught with difficulty, from lifelong health problems to a tumultuous marriage to larger, political commentary. Her early painting career was largely in the shadow of her husband, Diego Rivera, but she was able to garner recognition for her work in the late 1970s, and she was seen thereafter as a beacon of power and artistry for women, LGBTQ folks, and Mexicans. She suffered throughout her life from health problems, mostly stemming from a spinal injury in her adolescence. Despite physical and emotional pains, Frida continued to make work and participate in political causes as much as her body would allow.

ZAHRA NEMATI

Iranian Olympic and Paralympic athlete Zahra Nemati has won medals in both individual and team archery, and she has the unique experience of participating in both the Olympics and the Paralympics this summer. She began as a black belt in taekwondo. After a car accident left Zahra unable to use either of her legs, she turned to archery to find a renewal of her mental and physical strength. At the Paralympics in London in 2012, Zahra became the first Iranian woman to win a gold medal.

MALALA YOUSAFZAI

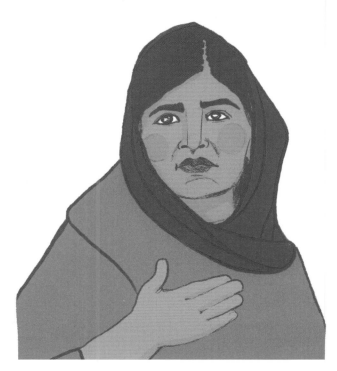

Malala began advocating for girls' education at the age of eleven. When she was twelve, she wrote under a pseudonym detailing the Taliban takeover of her country, and eventually she cultivated quite a bit of media attention. Her visibility while speaking out against the Taliban and advocating for girls' education made her a target for violence. In 2012, Malala survived an assassination attempt while riding the bus to school. Thankfully, she recovered and she has not stopped her mission of tapping all the potential that lies in the education of the babes of the world. In 2014, her efforts were recognized on a global scale when she won the Nobel Peace Prize and became the youngest person ever to receive the prize.

YUSRA MARDINI

Yusra and her sister fled war-torn Syria in August 2015, which required a month-long journey through Lebanon and Turkey and a journey across the Aegean Sea to get to Greece. The dinghy that carried them was only meant for six or seven people but instead held twenty. When the boat's motor failed and the dinghy began to take on water, Yusra and her sister (along with two other passengers who could swim) jumped out and pushed the boat for three hours until they reached Lesbos. They made their way through Europe and eventually settled in Berlin, where they met up with their parents. Yusra quickly resumed her athletic training and had her eyes on the Rio Olympics. In June 2016, Yusra was one of ten athletes chosen to be on the Refugee Olympic Team, where she competed in the 100-meter freestyle and 100-meter butterfly in Rio.

OPRAH WINFREY

Oprah is considered one of the most powerful women on the planet, and she is certainly one of the wealthiest. She's a household name due to her wildly successful talk show, her books, and her countless acts of philanthropy since her rise to stardom. But her beginnings were far from glamorous. She comes from a childhood of abuse, instability, and extreme poverty. She hopped from family member to family member as a child, living with whomever could take her in. She finally got some stability by living with her father in Nashville, where she thrived socially, emotionally, and academically. She eventually broke into media as an anchorwoman in Tennessee, which began her long, successful career as a television superstar.

"THINK LIKE A QUEEN. A QUEEN IS NOT AFRAID TO FAIL. FAILURE IS ANOTHER STEPPINGSTONE TO GREATNESS."

When you're going through hardship, no matter how big or small, come back to the stories of these women.

What can you carry with you to make you feel more capable of facing your day? Write or sketch some past or current hardships that you can connect with the stories of these women and many others.

"COWS RUN AWAY FROM THE STORM WHILE THE BUFFALO CHARGES TOWARD IT—AND GETS THROUGH IT QUICKER. WHENEVER I'M CONFRONTED WITH A TOUGH CHALLENGE, I DO NOT PROLONG THE TORMENT, I BECOME THE BUFFALO."

—*Wilma Mankillerr*
badass chief and leader from page 98

What other phrases or quotes offer a way to conquer those hardships? Write them in this space and come back to them when you need fuel for your fight.

"CREATIVITY IS AN ACT OF DEFIANCE. YOU'RE CHALLENGING THE STATUS QUO. YOU'RE QUESTIONING ACCEPTED TRUTHS AND PRINCIPLES. YOU'RE ASKING THREE UNIVERSAL QUESTIONS THAT MOCK CONVENTIONAL WISDOM:

'WHY DO I HAVE TO OBEY THE RULES?'

'WHY CAN'T I BE DIFFERENT?'

'WHY CAN'T I DO IT MY WAY?'

—Twyla Tharp

dancer, choreographer, and badass of the stage

MORE TALES OF BADASSERY

The world has no shortage of badass babes, and who wouldn't want to hear more inspiring stories? Let's continue to be inspired, shall we?

ELEANOR ROOSEVELT

Eleanor is among the most celebrated first ladies of American history. She was instrumental in getting her husband, Franklin Delano Roosevelt, to run for office, and thereafter, she never retreated into the background.

She took the opportunity to get more involved with politics, stepping into a realm that was un-occupied by women. She embraced the spirit of feminism that was burgeoning at the time, and she spoke out against racist practices, such as segrega-tion and the Japanese Internment Camps during World War II. She insisted on traveling throughout the country to personally promote and speak about numerous causes.

"You have to accept whatever comes and the only important thing is that you meet it with courage and with the best that you have to give."

Because of Eleanor's outspoken support of causes such as the civil rights movement, the Ku Klux Klan had a bounty on her head for a whopping $25,000! That didn't stop her from traveling the country to make her voice heard.

In the space below, draw your own portrait in solidarity and perhaps indicate a theme or cause you'd like to be courageous about.

WANTED
FOR BADASSERY

REWARD

ADVOCATES FOR EDUCATION

At the root of all conflict, at the heart of the urgency for progress, lies the need for education. Education can take many forms: it can be a classroom, a book, or two human beings sharing their life experiences. Yet, there remain countless obstacles to education for many. And these obstacles are being dismantled, one by one, by babes like these.

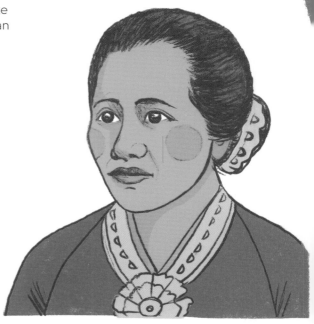

RADEN ADJENG KARTINI

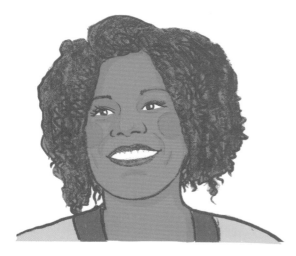

RUBY BRIDGES

Ruby is most known as one of the first black children to attend a newly desegregated school in 1960 in New Orleans. When Ruby was six, her parents were contacted by the NAACP, asking them to participate in the integration of the New Orleans school system. Ruby was given a test to determine whether she "qualified" to attend a white school. She was one of only six African American children to pass the test, and the only child to actually enroll in a white school. On her first day of school, there were so many angry crowds and protests surrounding the school, she had to be escorted to school by U.S. Marshals.

Ruby still lives in New Orleans, and in 1999, she created the Ruby Bridges Foundation, which works to educate and promote tolerance, respect, and the appreciation of all differences.

Kartini established herself in history as a pioneer for women's rights and the rights of natives in Indonesia. Kartini lived in Java in the early 1900s, when Indonesia was under Dutch colonial rule. She attended a Dutch-language primary school but had to enter seclusion in preparation for marriage, as was tradition. In seclusion, Kartini fueled her passions with European feminist readings and other progressive publications. She wrote letters to former classmates and instructors protesting the inequality embedded in Javanese traditions such as forced marriages. Kartini was not only concerned with the emancipation of women in Indonesia, but with equal opportunities for indigenous Indonesians, regardless of social status. In 1903, Kartini opened her own primary school for Javanese girls inside her father's home. She saw the ideal education for girls being rooted in emancipation and empowerment, promoting a desire for lifelong education.

DOLLY PARTON

Dolly is a recognized American icon for her music, acting, and unapologetic approach to her looks. What many don't know is that she is also the founder of an incredible organization that provides books for children. In 1995, Dolly launched the Imagination Library to promote literacy and foster a love of reading in children. It began in just her home county in east Tennessee, but has expanded all over North America and the United Kingdom. The organization mails one age-appropriate, expertly-chosen book per month to an enrolled child from the time they are born until they enter kindergarten. This service is free.

MICHELLE OBAMA

Among her many education initiatives taken while first lady, Let Girls Learn is a program that facilitates grassroots efforts around the world to develop programs for the education of girls and women. Michelle acknowledged that we have the privilege of free public education in the United States, and our girls and boys are equally welcome. That is not the case in all countries, however. Let Girls Learn works with local leaders to develop initiatives that can put long-lasting systems in place to give women and girls more access to education.

Aforementioned babes like Missy Elliott, Oprah Winfrey, and Malala Yousafzai have also been working to make education accessible to all!

Think about something new you've learned recently. Did you read it in the newspaper? See a documentary? Hear it on a podcast? Make it visual through writing or drawing (or both!) and find a way to share it.

"THE PROFUSION OF IGNORANCE THAT WE HAVE SEEN DEMONSTRATES THE HUNGER THAT CURRENTLY PERVADES EVERY CORNER OF OUR NATION.

THE ONLY WAY TO SATE THIS HUNGER IS TO EDUCATE."

—ILHAN OMAR

first Somali-American woman elected to a state legislature and Minnesotan badass

SPREADING AWARENESS

We often find ourselves living in bubbles, not always considering those whose life experience is outside the scope of our own lives or the lives of those immediately surrounding us. That's why advocacy, especially by those who are sharing their personal experience, is one of the most valuable kinds of education. When folks stand up and tell their stories, we need to listen! It'll not only help our friends, family, and neighbors feel validated, but it'll enrich our understanding of the world.

TEMPLE GRANDIN

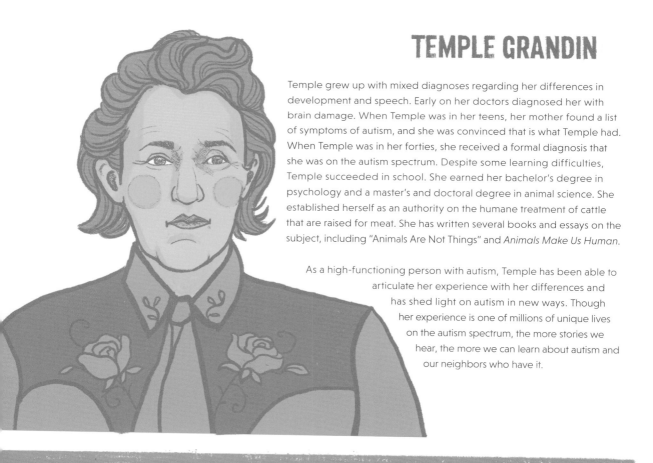

Temple grew up with mixed diagnoses regarding her differences in development and speech. Early on her doctors diagnosed her with brain damage. When Temple was in her teens, her mother found a list of symptoms of autism, and she was convinced that is what Temple had. When Temple was in her forties, she received a formal diagnosis that she was on the autism spectrum. Despite some learning difficulties, Temple succeeded in school. She earned her bachelor's degree in psychology and a master's and doctoral degree in animal science. She established herself as an authority on the humane treatment of cattle that are raised for meat. She has written several books and essays on the subject, including "Animals Are Not Things" and *Animals Make Us Human*.

As a high-functioning person with autism, Temple has been able to articulate her experience with her differences and has shed light on autism in new ways. Though her experience is one of millions of unique lives on the autism spectrum, the more stories we hear, the more we can learn about autism and our neighbors who have it.

SR. SIMONE CAMPBELL

Sister Simone is a Roman Catholic religious sister (a.k.a. nun), a lawyer, a poet, and a lobbyist for many social justice causes. When she began practicing law, she practiced family law and dedicated herself to helping the working poor in her community in Oakland, California. In 2004, she was recruited to become the executive director of NETWORK Lobby for Catholic Social Justice. Because of her sometimes conflicting with some official opinions of the Catholic Church, she has been admonished on numerous occasions. Her defense of a woman's right to choose in particular could have repercussions, including possible excommunication.

Regardless, Simone and NETWORK have continued to highlight social justice issues, including the Nuns on the Bus project, in which a group of nuns tour the U.S. to work with the poor and advocate for education and equal economic opportunities.

MARIA BAMFORD

Since taking up comedy at age nineteen, Maria has established herself as a unique and genuine voice in the comedy world. She has become known for her wide range of voices and impersonations in her act. (She's also a successful voice actor.) Bamford has woven stories of her experiences with depression, anxiety, and compulsion, and she openly speaks about her experiences in inpatient mental health centers and her diagnosis with bipolar II. Her ability to speak openly about her life and include it in her comedic repertoire makes room for a bigger, public conversation about mental health.

"YOUR OWN REASONS TO MAKE ART ARE REASON ENOUGH. CREATE WHATEVER CAUSES A REVOLUTION IN YOUR HEART."

—Elizabeth Gilbert

author, journalist, and creative badass

What do you experience regularly that you wish people knew more about? How can you take inspiration from the babes and spread the word? Start jotting down some key ideas below.

Could you think of a visual symbol or emblem that can help communicate your idea? How about a poem? A story? Explore some ideas on how to spread the word.

CHALLENGING BEAUTY AND BODY STANDARDS

We've already talked about the utter nonsense of the stereotypes revolving around gender, body, and identity. Much of the same can be said about the arbitrary standards of what is considered "beautiful." All of us, in one way or another, has come up against the impossible standards of what a human body should look like: whether it's skin tone, bone structure, weight, height, hair type, eye color, age—the list goes on. And on. And on. It's an uphill battle to fight, but luckily, we're gaining ground, thanks to babes like these:

LIZZO

Inspired by the likes of Missy Elliott, Lizzo is a rising hip hop musician whose message extends beyond her empowering lyrics. She has dedicated her time to making sure that women of all shapes and sizes are represented in her videos and performances. She is helping to spearhead movements like #EffYourBodyStandards, in which the priority is on talent, not arbitrary notions of what the ideal size of a singer, dancer, or any babe should be. Lizzo uses her voice to empower women to unapologetically embrace self-confidence, self-care, and strength.

LINDY WEST

Lindy is a writer, feminist, and activist who uses her mighty pen to shed light on social and political issues such as racism, sexism, and fat shaming. Lindy has used her personal experience as a self-described fat person to contribute to the fat acceptance movement. Lindy's powerful, witty, and joyous words have paved the way for humans of all shapes to talk openly about their bodies and eventually liberate themselves from much of the comparison and shaming that happens both online and in person. Between her hit book *Shrill,* and *I Believe You/It's Not Your Fault,* her advice blog for teens, Lindy's self-love serves as a powerful model for folks of all sizes and states of being.

UZO ADUBA

Uzo is a Nigerian-American actress who has taken the world by storm since the popular series *Orange is the New Black* debuted. She grew up struggling with unattainable beauty standards, as so many of us do. There was one trait that she was desperate to shake: the gap between her two front teeth. She has written and spoken about how, as a teen, she would beg her mother for braces and refuse to show her teeth in photographs. Her mother eventually explained how significant her gap was to her familial and cultural history: her family, both extended and immediate, all had that same gap in their teeth. And not only was her lineage embodied by that gap, but in Nigeria, a tooth gap signified intelligence and beauty. Uzo shares this story of turning self-consciousness into self-acceptance. She provides another great example of how beauty takes infinite forms, but it all starts with loving yourself as you are.

SELF-PORTRAITS

This is a hard battle to fight, but it's worth it. It's time to change any negative narratives you have about your body. Instead of focusing on what your body is not, focus on what it is: an amazing tool to navigate through your world and get shit done!

A wonderful thing happens when you connect what your body looks like with what is AWESOME. Take some time to explore, without judgment, the shape of your own bod. Once you find a way to depict it, show yourself doing things you're proud of: sports, reading, walking, talking, dancing . . . whatever you do best! Take time to draw yourself with the care and love that you'd show when drawing someone else. When you've reached a good stopping point, make sure you take a long, hard look at your work and say, "That is BEAUTIFUL." 'Cause it is.

In the space below, draw as many different body types and shapes as you can, all performing this pose.

"Be strong, be fearless, be beautiful. And believe that anything is possible when you have the right people there to support you."

Think about a goal you want to make happen.
Which people in your life can you count on to help and support you?
Who can you help and support?

MISTY COPELAND

Misty Copeland began dancing ballet at age thirteen, and she was already winning awards and receiving professional offers at fifteen. Today she is a dancer in the American Ballet Theatre, one of the three leading classical ballet companies in the United States, and she is the first African-American woman to be promoted to principal in ABT's history.

In addition to breaking these boundaries, Misty has challenged the idea of the ideal ballerina body. Not only does Misty have darker skin than any principal dancer, but her body exhibits strength, rather than the delicate, overly slim body type that has long been the status quo for ballerinas. Misty's body is that of an athlete because that's what dancers are.

Misty's hard work and talent have secured her place in ballet history, and hopefully this marks the opening of more doors for lots of different bodies to participate in ballet.

LADY BUSINESS:
BABES CHANGING THE WORKPLACE

Much of the corporate model of the workplace is based on patriarchal models that favor using fear and intimidation—reserving respect only for that which is hyper-masculine. In recent years, amazing minds have pointed out that this need not be the case, and that space can, and should, be made for all genders and identities in the workplace.

ANGELICA ROSS

SHERYL SANDBERG

Angelica is an essential voice in the public sphere, speaking on behalf of the transgender communities who are continuously marginalized and subjected to violence and discrimination. She has done so much already at such a young age. One of Angelica's many feats is founding TransTech Social Enterprises, an organization dedicated to giving professional and often lifesaving skills that trans people need to thrive in the workplace. TransTech provides on-the-job training in technology fields and teaches leadership skills to lift up those whose voices are seldom heard.

Sheryl is the chief operations officer of Facebook and the founder of the Lean In foundation. Sharing a name with her best-selling book, Lean In is an organization that provides education and leadership tools to help women thrive in the workplace and claim their seat at the table. The foundation uses small groups of peer-to-peer support, and community engagement to help remedy the drastic underrepresentation of women in the workplace, particularly in technology and senior levels of leadership.

Do you have any babe-owned or babe-run businesses in your area? How can you use your amazing creative talents to show how much you appreciate them? Can you write them a note? Draw them a comic expressing your admiration?

JUDICIARY BABES

In the United States, the Supreme Court consists of nine justices. It has a long history of being predominantly male and white, but that's starting to change! Here are the first female justices whose badassery is changing the landscape of the judicial branch in the United States.

SANDRA DAY O'CONNOR

Sandra was the first woman appointed to the U.S. Supreme Court. President Ronald Reagan appointed her in 1981, and she served until she retired in 2006. Sandra's career as a Supreme Court Justice was one spent advocating for women's rights, upholding Roe v. Wade, fighting against sexual harassment, and advocating for equal opportunity for women.

"Despite the encouraging and wonderful gains and the changes for women which have occurred in my lifetime, there is still room to advance and to promote correction of the remaining deficiencies and imbalances."

RUTH BADER GINSBURG

Ruth was the second woman appointed to the SCOTUS and the first Jewish woman to have the job. Since being appointed by President Bill Clinton in 1993, she's been fighting for women's equality for more than half a century and stands up against discrimination of all kinds. Folks, give a curtsy and a fist pump for our girl RBG.

"People ask me sometimes, when do you think it will it be enough? When will there be enough women on the court? And my answer is when there are nine."

"Each day on the bench I learn something new about the judicial process and about being a professional Latina woman in a world that sometimes looks at me with suspicion . . . I willingly accept that we who judge must not deny the differences resulting from experience and heritage but attempt, as the Supreme Court suggests, continuously to judge when those opinions, sympathies and prejudices are appropriate."

SONIA SOTOMAYOR

Sonia was the first Latina Supreme Court Justice and the third woman to hold the title. Since being appointed by President Barack Obama in 2009, Sonia has been a tireless advocate for Latino Americans and she has always been outspoken on issues of race, gender, and ethnic identity.

"No one has a monopoly on truth or wisdom. I've learned that we make progress by listening to each other, across every apparent political or ideological divide."

ELENA KAGAN

Elena's path to and arrival at the U.S. Supreme Court has included a series of firsts. Before being appointed to the Supreme Court in 2009, she served as the first female Solicitor General for President Obama. Her approval to join the Supreme Court put three females on the court at once—the most ever in the country's history.

The United States has nine. The United Kingdom has twelve. France's Cour de Cassation has more than 120 judges and deputy judges who serve. The numbers vary, but all countries' highest court contains some of the most powerful figures in the land.

Draw different kinds of babes that could make up the most badass Supreme Court ever. You can draw six or nine. And if you have the stamina for 120, knock yourself out!

CONTEMPORARY ACTIVISTS

We've explored activists from the past, but the torch is still being carried by babes in our present day. Here are some contemporary movers and shakers who have fought and are currently fighting for a cause that they believe in.

WINONA LADUKE

After graduating from Harvard with a degree in rural economic development, Winona moved to White Earth Reservation in northwestern Minnesota, where she began to work as an educator and an advocate for the Anishinaabe people. She helped found the Indigenous Women's Network as well as the White Earth Land Recovery Project. The recovery project bought back more than 1,200 acres of land within the White Earth Reservation, which had been bought by non-Native Americans, and it created a trust that could hold the lands in conservation.

The White Earth Land Recovery Project also works to revive and preserve the cultivation of wild rice, a crop that has a deep-seated and historical importance to the Anishinaabe people. Winona has continuously fought for the preservation of biodiversity and fought against the patenting and genetic modification of sacred foods of indigenous people.

VANDANA SHIVA

Vandana has argued for the wisdom of India's traditional Vedic practices and writes and speaks to topics of biodiversity, bioethics, globalization, and indigenous knowledge. She has been an outspoken opponent of corporate patents on seeds and has taken on many campaigns and battles against what she sees as "biopiracy." Vandana also plays a vital role in the Ecofeminist movement, arguing that positive changes in agriculture will only happen if people reject the "patriarchal logic of exclusion" and that all genders need to be engaged and work to change the system.

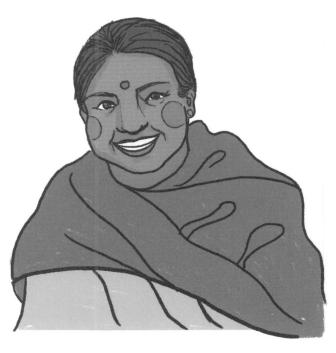

LAVERNE COX

Laverne has become one of—if not the— most visible transwoman in the public sphere. She is best known for her role as Sophia in the series *Orange is the New Black*, which landed her the first Primetime Emmy nomination for an openly transgender person. She was the first trans person to appear on the cover of *Time* magazine.

Laverne has also become a devoted advocate for the trans community, often taking on speaking engagements and op-ed writings to speak up about oppression and injustice that occurs regularly in the trans community.

MORE BADASSERY THIS WAY! ▶

ALICIA GARZA, OPAL TOMETI, AND PATRISSE CULLORS

Alicia, Opal, and Patrisse are the founders of the #BlackLivesMatter movement. These women have brought to light the ongoing systemic violence against black Americans, and they have taken a stand for black women and LGBTQ members of the black community, whose voices are not often heard. Since their founding of BLM in 2013, the message and power of the cause have made it a household term, and the movement has been at the forefront of social and political conversations in the United States and around the world.

RIGOBERTA MENCHÚ TUM

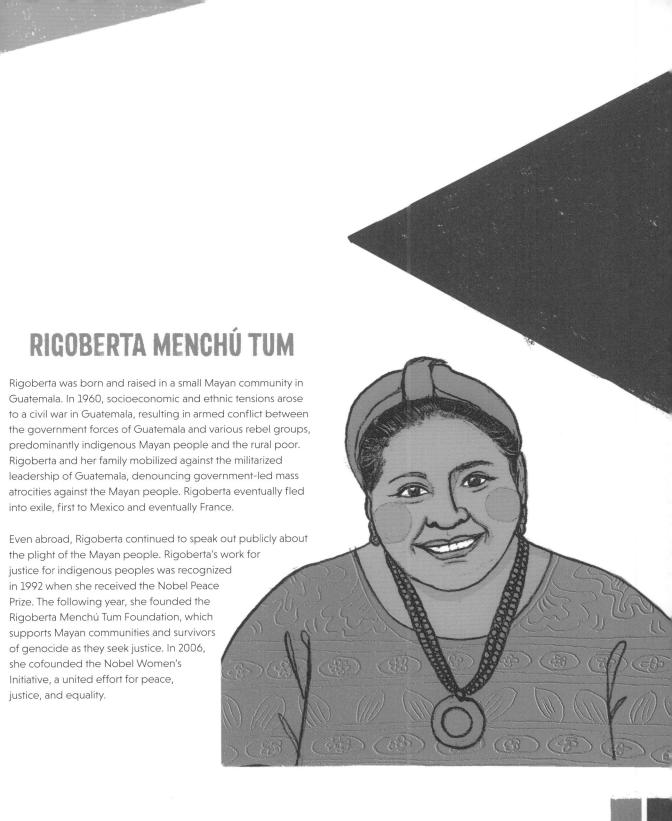

Rigoberta was born and raised in a small Mayan community in Guatemala. In 1960, socioeconomic and ethnic tensions arose to a civil war in Guatemala, resulting in armed conflict between the government forces of Guatemala and various rebel groups, predominantly indigenous Mayan people and the rural poor. Rigoberta and her family mobilized against the militarized leadership of Guatemala, denouncing government-led mass atrocities against the Mayan people. Rigoberta eventually fled into exile, first to Mexico and eventually France.

Even abroad, Rigoberta continued to speak out publicly about the plight of the Mayan people. Rigoberta's work for justice for indigenous peoples was recognized in 1992 when she received the Nobel Peace Prize. The following year, she founded the Rigoberta Menchú Tum Foundation, which supports Mayan communities and survivors of genocide as they seek justice. In 2006, she cofounded the Nobel Women's Initiative, a united effort for peace, justice, and equality.

We can all do things in our day-to-day lives to help further the causes we care about. What can you do to show your support? Read up! Educate yourself! Listen! Tell YOUR story!

What can you do in your day-to-day life to help further their cause and show your support? Make a short list of ways you can use your creative and brilliant talents help make a change.

CLOSING WORDS OF WISDOM

Of course, there aren't enough pages in the world to encapsulate all the badass stories of the past, present, and future. This workbook has many, but for every babe shown, there were countless others that were not. We could have tried to pack the pages to the gills, but in the end, the most important addition to the pages are your additions. Always feel empowered to come back and review, add, edit, or reflect. Your story is important, and it is inextricably connected to all the amazing babes of history.

Taking action to empower yourself and others can feel a lot like creative work: you often feel like you can't start until everything is perfect and you are 100 percent ready. That's just not realistic. If you take time to know your worth, know your strengths and weaknesses, and know that you are in pursuit of sharing your story and learning the stories of others, you can start right now. None of us is 100 percent perfect, 100 percent ready, or 100 percent enlightened. That's why we need to hear from each other—and learn from one another. The sum of all of us: that's perfection. That's badass.

I leave you with a quote from the prolific, inspiring, badass writer Roxane Gay, whose work is chock-full of babely wisdom. Her book, *Bad Feminist*, has a title that encapsulates the imperfection that is inherent in all progressive and creative work.

"I EMBRACE THE LABEL OF BAD FEMINIST BECAUSE I AM HUMAN. I AM MESSY. I'M NOT TRYING TO BE AN EXAMPLE. I AM NOT TRYING TO BE PERFECT. I AM NOT TRYING TO SAY I HAVE ALL THE ANSWERS. I AM NOT TRYING TO SAY I'M RIGHT. I AM JUST TRYING— TRYING TO SUPPORT WHAT I BELIEVE IN, TRYING TO DO SOME GOOD IN THIS WORLD, TRYING TO MAKE SOME NOISE WITH MY WRITING WHILE ALSO BEING MYSELF."

—ROXANE GAY

author, professor, and badass feminist

BABE INDEX